CAMERAS

Copyright © 1981, Raintree Publishers Inc.

Library of Congress Number: 80-17413

2 3 4 5 6 7 8 9 0 84 83 82

Printed and bound in the United States of America.

Library of Congress Cataloging in Publication Data

Bostrom, Roald.
 Cameras.

 (A Look inside)
 Includes index.
 SUMMARY: Discusses the history of the camera and
describes the parts of a basic camera and how they
work. Also explains the function of different
lenses, and other attachments and how film is
developed.
 1. Photography — Juvenile literature.
2. Cameras — Juvenile literature. [1. Photography.
2. Cameras] I. Baldini, Tony. II. Title.
III. Series: Look inside.
TR149.B53 771'.3 80-17413
ISBN 0-8172-1404-6 (lib. bdg.)

CAMERAS

By Roald Bostrom

Illustrated by Tony Baldini and Roald Bostrom
Cover illustration by Mark Mille

CONTENTS

WHAT IS A CAMERA?	5
THE INVENTION OF THE CAMERA	9
THE PARTS OF A CAMERA	15
MAKING THE PICTURE	23
CONTROLLING THE LIGHT	31
KINDS OF CAMERAS	37
EXTRAS	43
GLOSSARY	46
INDEX	47

RAINTREE PUBLISHERS
Milwaukee • Toronto • Melbourne • London

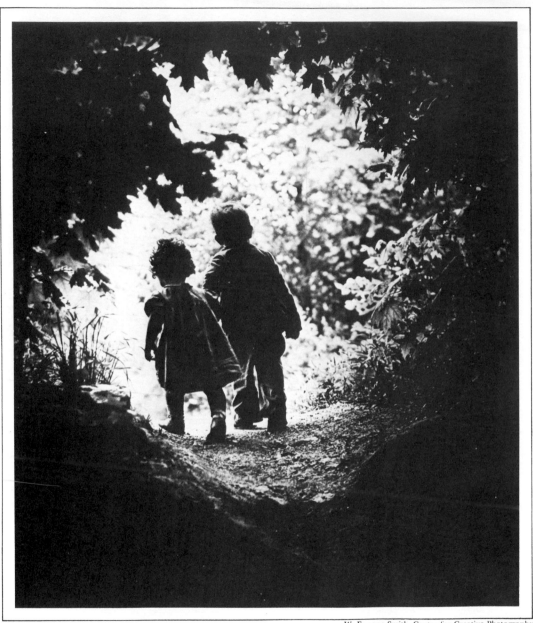

W. Eugene Smith, Center for Creative Photography

4

WHAT IS A CAMERA?

Everyone knows what a camera is; it's a box that makes pictures. The pictures made by a camera are called photographs, and we are surrounded with photographs. Look around you. There are photographs in schoolbooks, magazines and newspapers. There are photographs on buttons, billboards and bulletin boards. There are even photographs in our homes.

To make so many different kinds of photographs requires many different kinds of cameras. For example, to make good photographs of the stars and planets an astro-camera is needed. To make good photographs thousands of feet below the surface of the ocean, underwater cameras are needed. There are even special cameras used for taking photographs of people. These are called portrait cameras. And, of course, the cameras used to make movies are called cinema cameras or motion picture cameras.

"The Walk to Paradise"

W. Eugene Smith (1918-1978) took this photo of his children in 1946.

5

In spite of the numbers, dials, adjustment rings, catches, levers and buttons, almost all cameras work in the same way. A modern camera consists of a box which holds special picture-recording material called film at one end. At the other end is a small hole with a door. Light from a scene passes through the hole and the open door and strikes the film. When that happens, a small picture of the scene is recorded on the film.

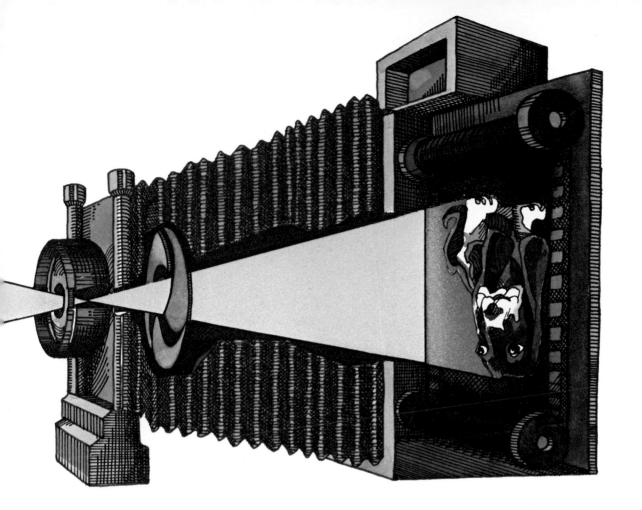

How to make a simple camera

Cut off one side of a cardboard box. Cover that side with wax paper. Cut a small hole (about 1 cm on a side) in the side of the box facing the wax paper. Take the box into a darkened room with one bright light and point the pinhole at the light. You should see an image of the light on the wax paper. Move the box back and forth until the image is focused.

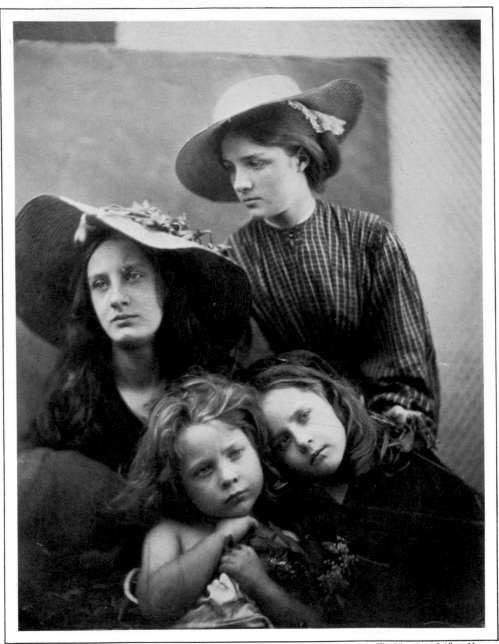

The Victoria and Albert Museum

8

THE INVENTION OF THE CAMERA

"Summer Days 1865"

Julia Margaret Cameron is thought of as one of the greatest portrait photographers of the nineteenth century.

It may seem strange, but today's camera began many years ago as a room. Stranger yet, it had nothing to do with photography, but a lot to do with astronomy (the study of the stars and planets).

Almost 950 years ago Arab scholars knew of a way to look at an eclipse of the sun without hurting their eyes. They chose a room, like a room in a house, and sealed it off so that no sunlight could enter around the doors and through the windows. After doing this, they drilled a tiny hole in the ceiling or wall that faced the sun.

The sunlight passed through the hole and fell upon the wall or floor across from the hole. It appeared as a little round circle. This circle of light was actually a little picture of the sun. As the moon crossed the face of the sun, as it does during an eclipse, a round shadow would seem to move across the circle of light on the floor.

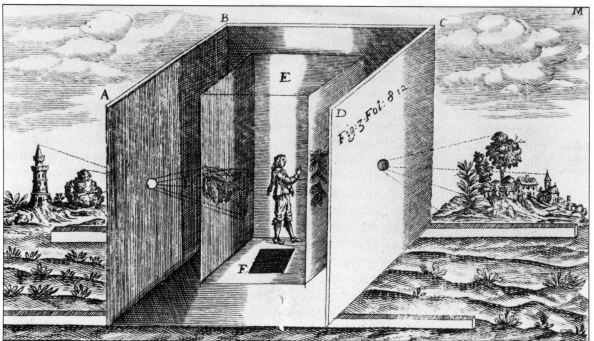

George Eastman House

This engraving from 1646 shows a *camera obscura*. Light from the scene outside was focused through the holes. The same scene then appeared on the clear inside walls.

With this room, scholars could see an eclipse without looking right at the sun. The room was later called by the Latin name *camera obscura,* or "darkened room."

Another use for the room was soon found. Instead of drilling the tiny hole so it faced the sky, the hole was drilled in a wall so that it faced the countryside. It was found that on a very bright day the light passing through the hole made an image on the opposite wall that was exactly the same as the scene outdoors in front of the tiny hole!

There were some problems. The picture was dim, and it wasn't perfectly sharp. Experimenters soon found that they could place a lens over the hole, which made the image sharper and brighter.

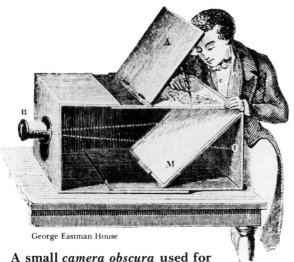

A small *camera obscura* used for tracing pictures.

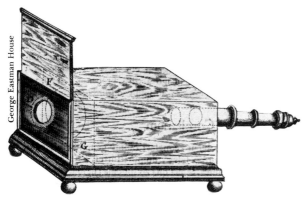

A portable wooden *camera obscura*.

Two related ideas soon brought the camera obscura to its peak of development. The first was the idea that a person could use it as an aid to drawing. All you had to do was trace the image on the wall with a pencil. But since it was a room, it was impossible to take the camera obscura with you, say, to the country where you could trace different scenes.

The answer to this problem was the second idea — make the camera obscura small enough to carry. By 1700, the camera obscura was reduced to the size of a shoe box. A mirror was added, and the image, instead of being formed on a surface opposite the hole, was reflected up by the mirror to the top of the box where a piece of frosted glass was fixed. Tracing paper was placed over the glass, and the image formed on the underside was easily traced.

Once the image appeared sharp on the viewing glass, it was easy to make a picture. All one had to do was place a piece of tracing paper over the glass and trace the picture with a pencil. People had a lot of fun making camera obscura pictures, but it soon became clear that even if one were very skillful at tracing, the picture didn't appear exactly like the scene.

Quite naturally inventors tried to think of a way to make the scene actually stick to the paper. Finally, in 1826, success — the first photograph was made! A Frenchman named Joseph Niépce succeeded in making permanent on a metal plate a view of a barnyard from his window. He covered the metal plate with a substance that turned dark when light hit it. He had to leave the plate out for hours before he got the picture.

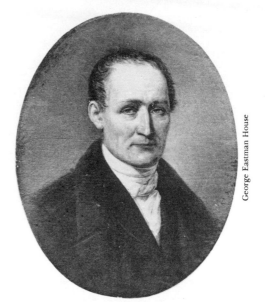

Joseph Niépce

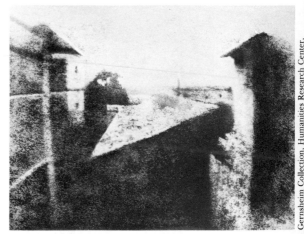

The first photograph, made in 1826 by Joseph Niépce. It shows the yard behind the Niépce family house, with the slanting roof of a barn in the middle.

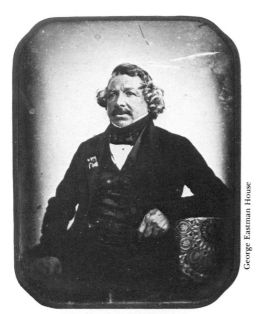

Francois Daguerre

A daguerreotype in its case

Almost ten years later, in 1835, an Englishman named William Henry Fox Talbot succeeded in fixing even clearer pictures to paper. In 1839, two German scientists, Franz von Kobell and August von Steinheil, also fixed images on paper. However, it would be another Frenchman in the same year, 1839, who would be even more famous.

Francois Daguerre had worked with Joseph Niépce for several years. In 1833, Niépce died, but Daguerre continued working. In 1837 he succeeded. In 1839, after a few improvements, his process was presented by the French government to the world. It became the first photographic process to have worldwide success. The pictures, which appear on a highly polished silver copper plate, are very beautiful and detailed. They are called daguerreotypes, and they can still be found in antique stores today. They look very shiny and are usually held in small leather cases.

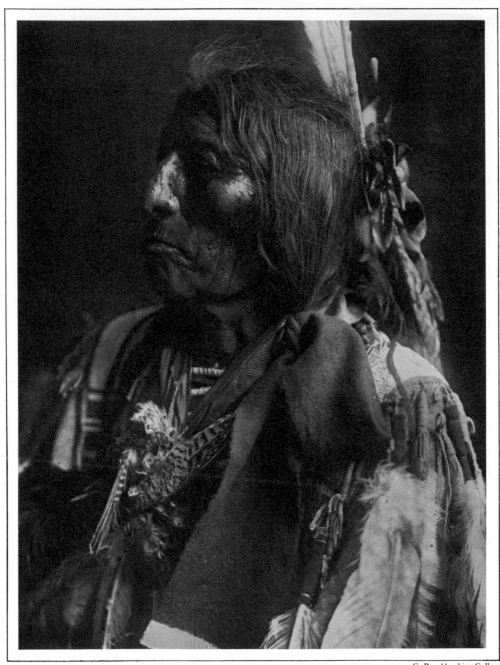

14

THE PARTS OF A CAMERA

By 1840, the instrument that formed the picture was simply called the camera; the word obscura was dropped from the original name. Eventually new features were added to the camera. One of these was a shutter.

The shutter acts as a door to the camera. It is usually found just behind the lens. When open, light may pass into the camera. When closed, light is blocked from entering the camera. To make a picture, just a little light is needed. The shutter is opened and shut quickly, allowing just a small amount of light to enter the camera.

"Slow Bull"

Edward S. Curtis (1868-1952) is best known for his 30-year effort to photograph the last of the North American Indians.

The photographer can set the shutter so that it opens and closes at different speeds. The numbers of the shutter speed settings are usually marked on the shutter speed dial. The numbers are often marked as follows: 1, 2, 4, 8, 15, 30, 60, 125, 250, 500, and 1000. Number 1 stands for 1 second. Number 2 stands for ½ of a second. Number 4 stands for ¼ of a second and so on, each number being a fraction of a second. Number 1000 causes the shutter to stay open for 1/1000 of a second. These different speeds allow the photographer to pick the right one for each picture.

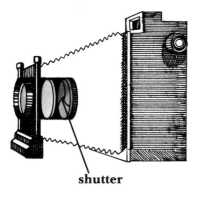

shutter

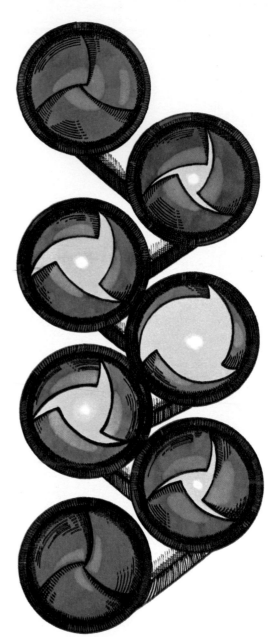

The leaves of a shutter open and close in a fraction of a second.

Another feature added to the camera was the adjustable aperture. The aperture is the little hole in front of the camera. On modern cameras there is an aperture adjustment ring which allows the photographer to make the aperture bigger or smaller. If it is made bigger, more light will enter the camera. If it is made smaller, less light will enter the camera.

The numbers showing the size of the aperture are called by a strange name — f-stop numbers. The aperture adjustment ring is usually marked as follows: 2.8 (called two eight), 4, 5.6 (called five six), 8, 11, 16, and 22. The larger the number, the smaller the opening. Thus, opening number 2.8 will be large and permit a lot of light to enter as compared with, say, aperture opening number 22 which is small. Both the correct shutter speed and f-stop number must be set to make a good picture.

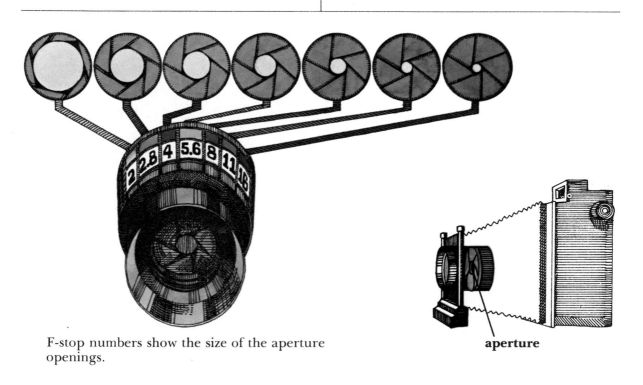

F-stop numbers show the size of the aperture openings.

aperture

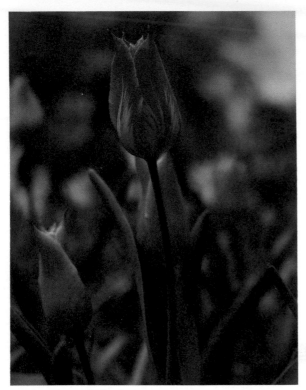

A photograph in focus

A photograph out of focus

Roald Bostrom

The lens is a particularly important part of modern cameras. It is made of special glass that has been polished and ground to an exact shape. Often it is made of several curved parts. Its job is to take each tiny ray of light from a subject, for example a tree, and bend that ray of light so that it lands on a certain spot on the film plane of the camera. The film plane is where the film is located.

When the tiny rays of light are brought together on the film plane, the subject, in this case the tree, will appear sharp. As you can imagine, there are millions of these tiny rays coming from the tree. If the lens were not adjusted properly, the rays of light would not meet properly and the tree would look blurry. Adjusting the lens is called focusing the camera.

A photograph taken with a regular lens

Roald Bostrom

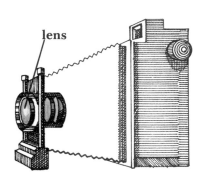

lens

Different kinds of lenses can be attached to many modern cameras. Each lens gives a different angle of view, and they range from wide-angle to telephoto. The telephoto lens has a very narrow field of view, but acts like a telescope. It makes a distant object appear closer than it really is. The wide-angle lens will include a lot of area around the subject, and may cause it to appear very far away.

In between those extremes are a whole variety of lenses which provide different kinds of views. Most pictures are taken with lenses in between very wide-angle and telephoto. A new kind of lens which is being made lets the photographer adjust to either telephoto or wide-angle. This is called a zoom lens. The photographer's choice of lens depends upon the kind of picture he or she wants to make.

19

A photograph taken with a telephoto lens

A photograph taken with a wide-angle lens

Roald Bostrom

telephoto lens

wide-angle lens

a roll of film

a cassette holding film

a single sheet of film

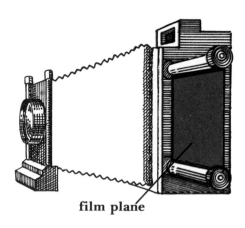

film plane

Inside all cameras is a place to put the material that will record the picture. This material is called film. It is placed at the point where the lens makes the scene sharp. This place is called the film plane. In most cameras a whole roll of film is placed in the camera, and it is moved across the film plane one picture frame at a time. One roll may permit the photographer to take as many as 36 pictures before inserting a new roll of film. The part that moves the film is called the film advance lever or knob, depending upon the type of camera.

As you can see, there are a lot of parts in a camera. To understand how all of these parts work together, you should learn more about the special recording material called film.

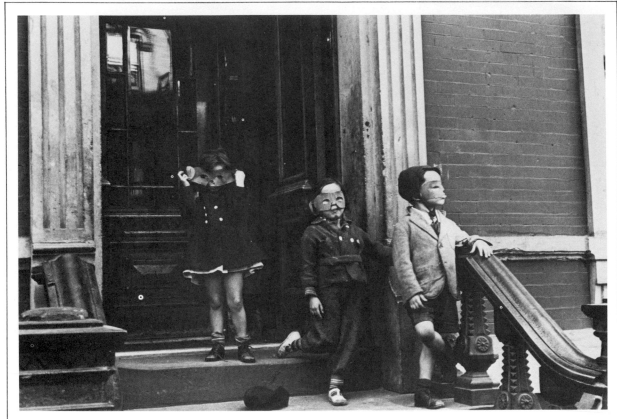

Helen Levitt

MAKING THE PICTURE

As we said earlier, the film is placed at the point in the camera where the light is focused into a picture by the lens. This point is called the film plane. When the shutter release button is pushed, the shutter opens and closes. Light from the scene enters the camera. The light goes through the lens and the aperture and strikes the film. A tiny picture of whatever the camera was pointed at is formed there and recorded by the film. What is truly amazing is that during the brief moment the shutter opens and closes (only a fraction of a second), the film is able to "remember" the view toward which the camera was pointed.

"Children"

In photographs like this one, from 1940, Helen Levitt can show the humor and drama in everyday situations.

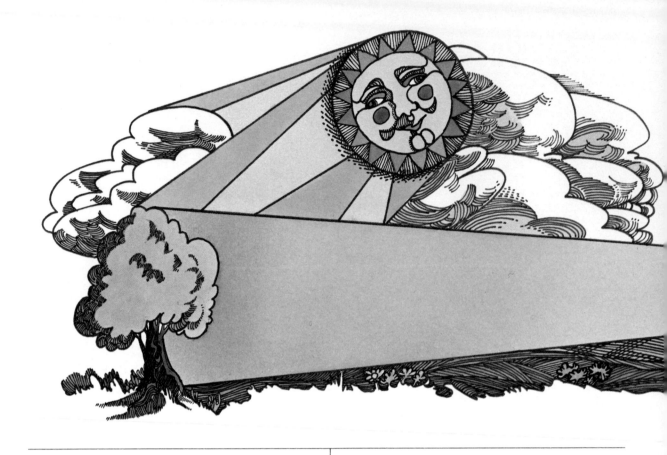

Film turns dark when light hits it, the way your skin gets darker in the sun. If a lot of light strikes the film in the camera, the film will turn very dark, almost black. If no light strikes the film, it will remain clear or transparent. If some light strikes the film, but not a great deal, the film will turn sort of gray. As more light strikes the film, the film becomes darker and darker.

How does an image appear on the film? Every scene is made up of different objects, for example houses, trees, people, and mountains. Every object reflects differing amounts of light toward the camera. This reflected light lets us see objects and tell them apart. This light is also recorded in black and white tones on the film.

24

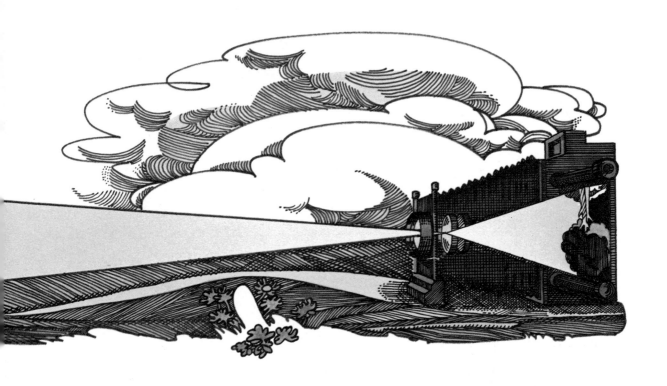

An example might help. Pretend that you are the photographer, and that you are going to take a picture of a large dark tree with bright green leaves. First you focus the lens so the shapes are sharp. Then you press the shutter release button to allow a small amount of light from the scene to enter the camera and strike the film. The leaves, which are a pale color and reflect a lot of light, will look dark on the film. The tree trunk, which is darker than the leaves, reflects only a little light and will look lighter on the film. The picture of the scene is now stuck to the film, but you can't see it. The picture must be developed first.

Once the pictures have been taken, or, as photographers put it, once the film has been exposed, the pictures are ready to be developed. In total darkness the film is taken from the roll or cartridge and put in a special chemical called developer.

The film is next put in a liquid called fixer. This protects the picture from the light. Finally, the film is washed in clean water and hung to dry. Now you can turn the lights on. When you look at the picture, you will see that all the tones are reversed. White objects look black and black objects look white. This kind of picture is called a negative.

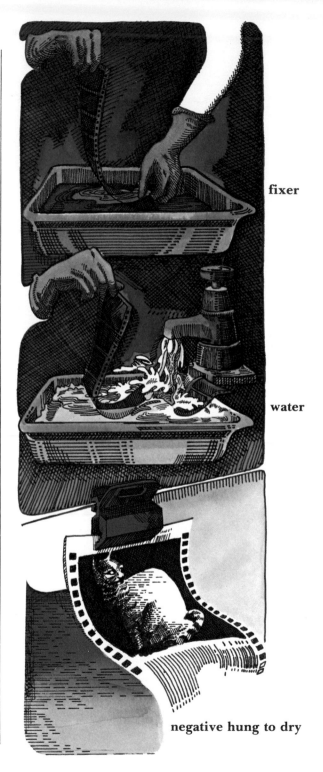

fixer

water

negative hung to dry

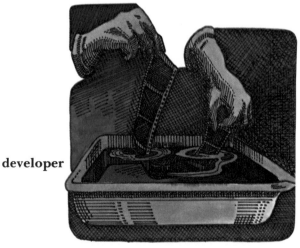

developer

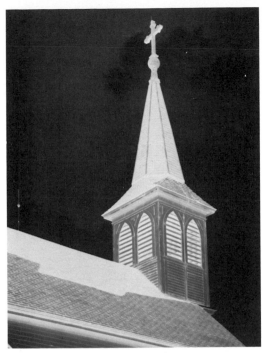

Negative of church steeple

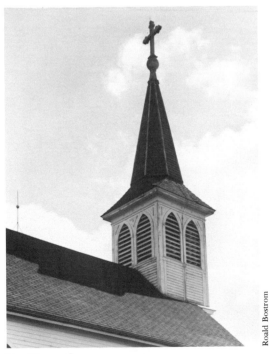

Positive of same scene

Roald Bostrom

One more step must be taken before the final picture — the print — can be made. The negative is placed on top of a piece of photographic paper. This paper acts just like the film. That is, after development it will be dark where light struck it and lighter or white where little or no light struck it. When the negative is placed on top of the paper, a light is turned on for a few seconds and then turned off. The paper is then developed in the same kind of chemicals.

Imagine you have taken a photo of a dark church roof and steeple against a bright sky. In the negative the roof will be light. A good deal of light can pass through that part of the film to the paper. So the roof on the paper will appear dark, as it did in the actual scene. The sky, which was dark on the negative, appears light on the paper. This is because hardly any light was able to pass through that part of the negative. All the tones are made normal on the final print. This print is called the positive.

So far we have only talked about black-and-white pictures. What about color pictures? Before the twentieth century, colored pictures were made by hand-coloring black and white pictures. In 1907, the Lumiere brothers of France made the first successful color photographs. And by the mid 1930s both the American firm of Eastman Kodak and the German firm of Agfa were producing the first of the modern-day color films.

An early photo

The same photo, hand-colored

Courtesy of the author

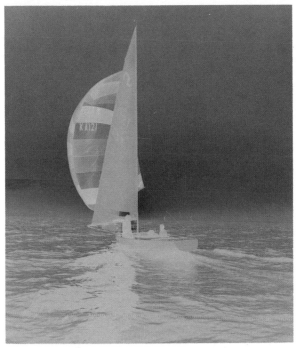

color negative

These films make two different types of colored pictures — transparencies, or slides, which are viewed on a movie screen, and colored prints. The color print is made from a negative, like a black-and-white print, but it must be a color negative. Colored pictures are made in the same way as black-and-white pictures. The difference is that chemicals are present in color films which reproduce the color of the original scene.

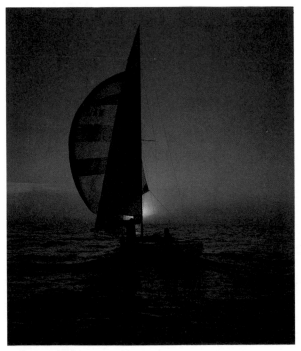

color print

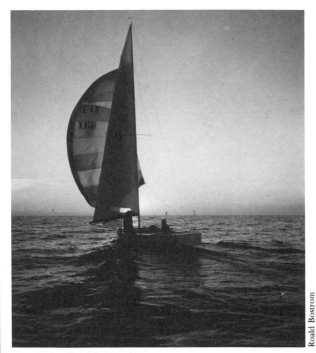

Roald Bostrom

black and white print

29

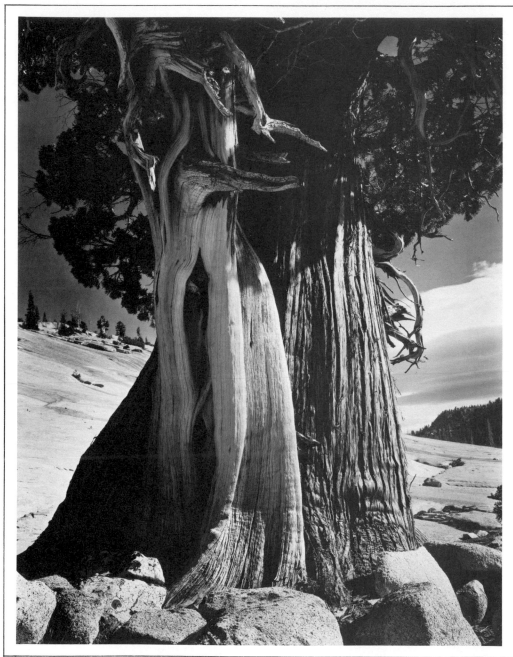

Edward Weston

30

CONTROLLING THE LIGHT

The problem with film is that it is very sensitive to light. The photographer must make sure that just the right amount of light from a scene strikes the film. Too much or too little light will ruin the picture. To expose the film properly to light, the photographer uses an instrument called a light meter. This measures the light being reflected from a scene toward the camera. The meter will show the combinations of shutter speed numbers and aperture f-stop numbers which can be used to make a good picture. Which combination to use is decided by the photographer. Any one of the combinations shown by the light meter will work.

However, before the photographer measures the light, he or she must adjust the meter so that it will work correctly with the film being used. This is necessary because films differ in their sensitivity to light.

"Juniper, Lake Tenaya, 1938"

Edward Weston (1886-1956), a famous American photographer, is known for his sharp, realistic photographs.

Look for the ASA number marked on the film instructions. (ASA stands for the American Standards Association, which tests the film.) The higher the number, the greater the sensitivity and the less light is needed to make a good exposure. A low number, for example ASA 25, shows that the film is not so sensitive to light as a film marked ASA 400.

To adjust the meter, the pho-

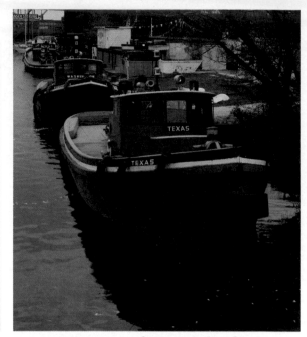

correct exposure — f-stop number f8

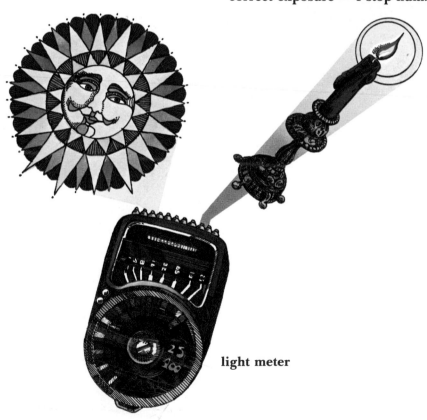

light meter

underexposed photo — f-stop number f16

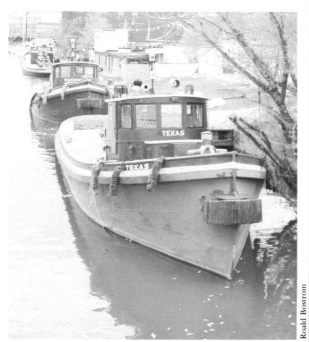

overexposed photo — f-stop number f2.8

Roald Bostrom

tographer turns a dial on the instrument until a pointer points to the ASA number shown on the film instruction sheet.

You are probably wondering why it is necessary to have so many different f-stop numbers, shutter speed numbers and films with different ASA numbers. The reason is flexibility. For example, suppose a photographer were going to take a picture of a person seated at a table in a room lit only by one candle. That is not very much light for taking pictures. To do the job, the photographer would choose a film that is very sensitive to light (high ASA number). Then he or she would choose a shutter speed and aperture setting combination which would allow enough light to enter the camera to properly expose the film. As you can see, the decision as to film and settings was determined by the light for the picture. Different films and adjustable cameras let the photographer work in many different kinds of light.

Another reason for an adjustable camera has nothing to do with lighting. Sometimes it is necessary to stop action. For example, if the photographer is taking pictures of a sports car race, and he or she uses a slow shutter speed, the cars will look blurry. If, however, the photographer chooses the shutter speed-aperture combination that gives the fastest speed, he or she may be able to "freeze" the action of the cars, thus causing the cars to appear sharp in the photograph. The photographer may find, nevertheless, that a little blurriness adds to the effect of the picture.

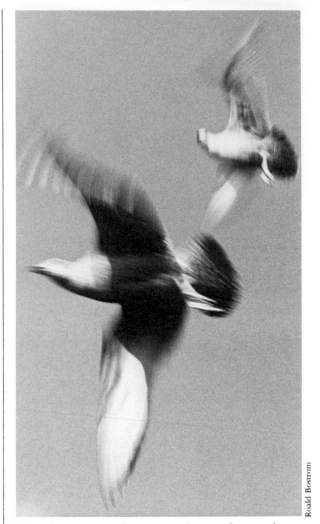

Roald Bostrom

The shutter speed was too slow to freeze the action of the seagulls. The blurriness helps to give the feeling of motion.

There are times when the photographer doesn't have enough light to make a picture. He or she must then add light to the scene to be photographed. The photographer has a choice of two types of extra lighting — tungsten and flash. Tungsten lights are simply large light bulbs placed in metal reflectors. They burn steadily to give enough light for the picture.

Flash is different. It lasts only a fraction of a second but is very brilliant. It is timed to occur when the shutter is wide open. Flashes can be created by small bulbs attached to a camera (flashbulbs) or by electronic flash guns, which can also be attached to the camera. The flash in the bulb is caused by burning of a special metal. The flash in a gun is caused by a tiny but very bright electric spark, much like a miniature bolt of lightning.

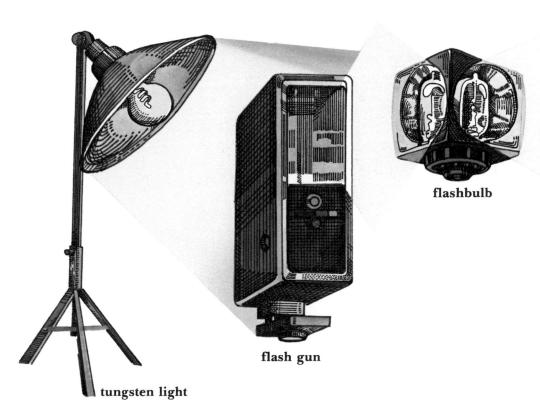

flashbulb

flash gun

tungsten light

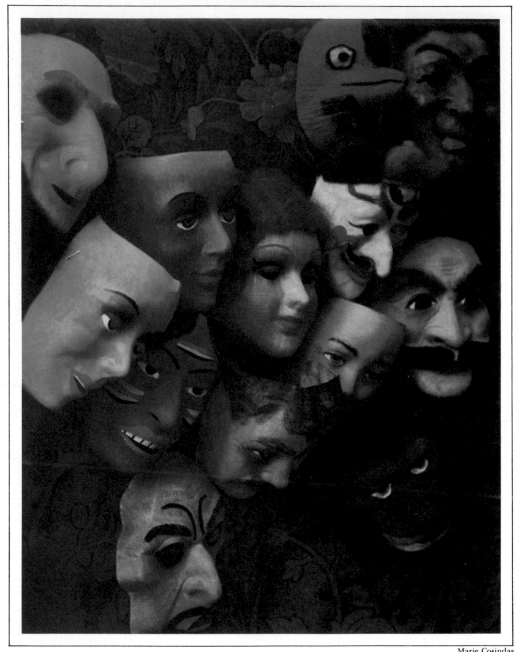

Marie Cosindas

KINDS OF CAMERAS

Cameras are sometimes referred to by the size of film that they use. For example, a camera that uses 4 x 5 inch film will often be called a four by five. A 35 millimeter camera makes pictures on film which is 35 millimeters long. Nevertheless, modern cameras are properly named by the viewing and focusing system used. There are four general categories: the single lens reflex, the rangefinder, the twin lens reflex, and the view camera.

The single lens reflex (SLR) camera has become popular during the past twenty years. Of all the different cameras, this one is most like the old camera obscura. With the single lens reflex camera, the photographer views and focuses the scene by looking out through the lens of the camera. By turning the focusing ring, the whole scene becomes either blurry or sharp. If the scene looks sharp it is in focus.

"Masks"

Marie Cosindas is well known for her color photography.

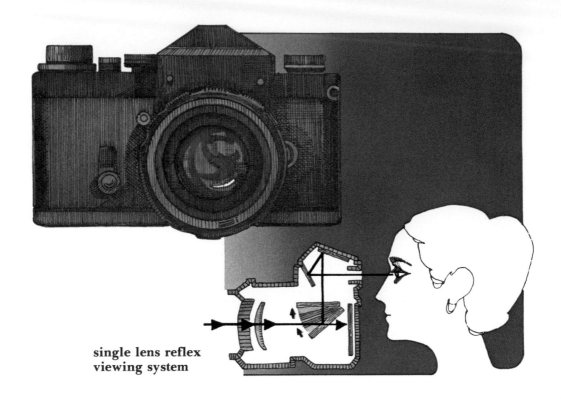

**single lens reflex
viewing system**

Light from a scene passes through the lens and aperture, and is reflected up to the viewing prism by a mirror. When the photographer presses the shutter release button the mirror jumps out of the way, allowing the light to pass to the shutter. The shutter opens and closes and the light hits the film. The shutter on an SLR is located almost on the film or focal plane. For this reason it is called a focal plane shutter.

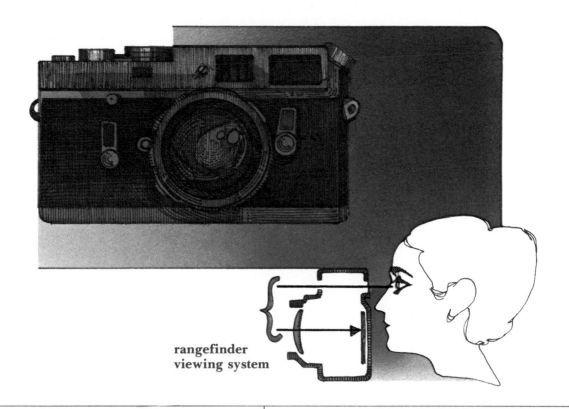

rangefinder viewing system

In the past the rangefinder camera was the most popular camera with both amateurs and professionals. The rangefinder camera takes its name from the fact that the viewfinder, which usually was located above the lens on top of the camera, held a mechanism for finding the exact distance between the camera and the subject. This made it possible to focus the lens accurately.

The rangefinder camera works in the following way. Suppose you are looking through the viewfinder at a tree which you are about to photograph. You will see two identical trees, or one split in half. By turning the focusing ring on the lens, the trees will appear to move further apart or closer together. To focus, you turn the focusing ring until the two trees merge into one. If you look at the distance scale on the lens focusing ring, you can read off the distance in either feet or meters.

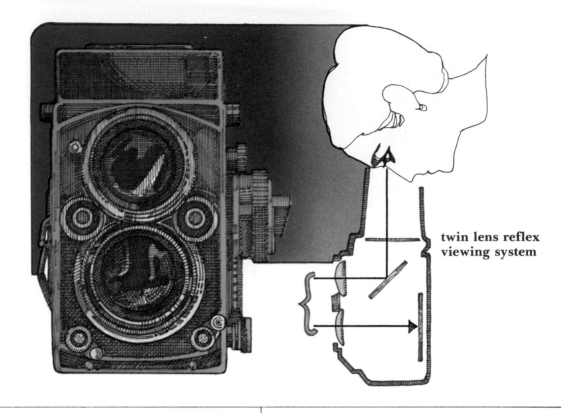

twin lens reflex
viewing system

The twin lens reflex (TLR) uses a viewing and focusing system somewhat like the single lens reflex. However, instead of using just one lens for taking and viewing the scene, the TLR uses one lens for taking the picture and one lens for viewing and focusing the scene. The lenses work together, so that by focusing the scene with the top lens you are focusing the picture-taking lens on the film plane at the same time. Most twin lens reflex cameras are used by holding the camera at waist level and viewing the scene as it appears on a piece of glass on the top of the camera.

The fourth camera is the view camera. This is the one you think of when you think of old-time photographers. It is always used with a tripod, and the

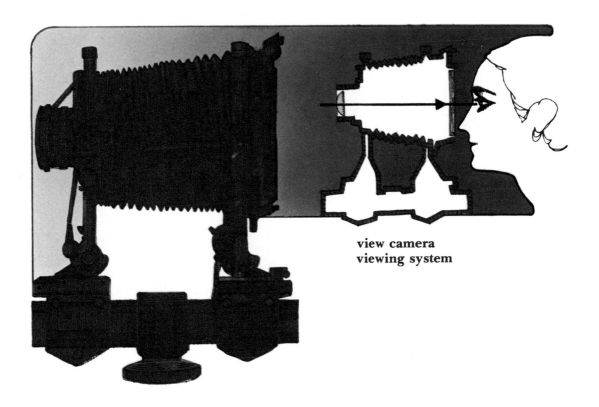

**view camera
viewing system**

photographer covers him or herself and the back of the camera with a dark cloth. The cloth blocks out daylight, making it easier for the photographer to see the image. This camera uses individual sheets of film varying in size from 4 x 5 inches to 16 x 20 inches!

Another camera you may know is the "snapshot" or "pocket" camera. This is not really a different category of camera, but refers to how people use the camera. A snapshot is simply a record of our friends, relatives, children at a party or a family gathering. Most of these cameras are small and easy to use. Some are so simple that they need no focusing or setting of speeds or apertures. Film is often found in the form of plastic casettes which are dropped into the back of the camera.

41

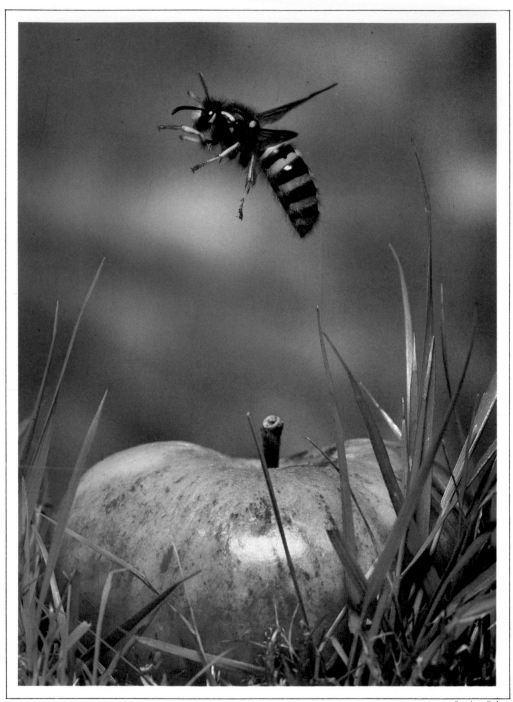

Stephen Dalton

EXTRAS

As mentioned earlier, some light meters are built into the camera. This can be very convenient because the photographer only has to carry one object — the camera. Some cameras with built-in light meters are automatic. That is, the light meter will measure the light from a scene and set either the shutter or the aperture. For example, if the photographer chooses a shutter speed, the light meter will automatically select and set the correct f-stop number. Or the photographer might set a particular f-stop number, and the light meter will select the correct shutter speed. If, by chance, the light level is too low to make a good picture, the light meter will signal this fact to the photographer with a red light in the viewfinder.

"Wasp over Apple"

Stephen Dalton is an English naturalist and photographer. He designed a whole camera and lighting system himself. With this system he got the fast shutter speed and bright lighting he needed to freeze the insect's motion.

43

Another favorite item used by photographers is the tripod. This is a portable stand for the camera to rest on. Its purpose is to hold the camera very steady during the taking of a picture, particularly if the shutter is set for a very slow speed.

There are also devices that work the shutters by remote control. These are useful when the camera is in a place where the photographer may not stand, as on top of a pole, or where the photographer's presence may interfere with the picture. Bird photographers often use these radio "trippers," as they are called.

Other accessories include dozens of different kinds of light filters, each of which changes the color of light coming into the camera. There are many accessories for solving different picture-taking problems.

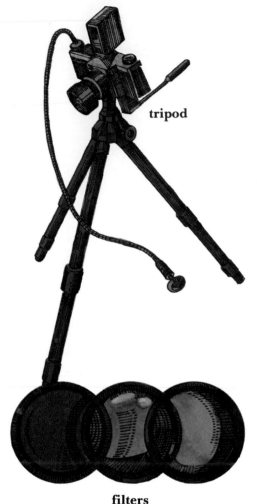

tripod

filters

underwater camera case

motor-driven camera

Photography has come a long way since Francois Daguerre's invention back in 1839. Aside from still cameras, there are movie cameras for making motion pictures. There are X-ray cameras which doctors use to photograph your bones and organs. There are electronic cameras without film or paper. These are television cameras.

There are many special cameras for special purposes, but the most common camera is the still picture camera. As we said at the beginning, everyone knows what that is. However, not everyone knows how it works . . . but you do.

snapshot camera

PRONUNCIATION GUIDE

These symbols have the same sound as the darker letters in the sample words.

ə	balloon, ago
a	map, have
ä	father, car
b	ball, rib
d	did, add
e	bell, get
f	fan, soft
g	good, big
h	hurt, ahead
i	rip, ill
ī	side, sky
j	join, germ
k	king, ask
l	let, cool
m	man, same
n	no, turn
ō	cone, know
ȯ	all, saw
p	part, scrap
r	root, tire
s	so, press
sh	shoot, machine
t	to, stand
ü	pool, lose
u̇	put, book
v	view, give
w	wood, glowing
y	yes, year
′	strong accent
′	weak accent

GLOSSARY

These words are defined the way they are used in the book.

aperture (ap′ ər chur′) the small hole in front of the lens that allows light to enter a camera

develop (di vel′ əp) to treat exposed film in chemicals in order to bring out the picture

developer (di vel′ əp ər) the chemical solution that brings out the picture on exposed film

expose (iks pōz′) to allow light to strike photographic film

f-stop number (ef′ stäp nəm′ bər) the number that shows the size of the aperture

film (film) a special material that records the images carried in light

film plane (film plān) the point inside the camera where the focused light rays meet the film

fixer (fiks′ ər) the solution that stops the action of the developing chemicals and fixes the image permanently on the film

flash (flash) a device that gives off a quick burst of light

lens (lenz) a curved glass that focuses light rays

negative (neg′ ət iv) a picture on film that has the dark and light tones reversed

positive (päz′ ət iv) a photograph in which the light and dark tones are the same as the original scene

print (print) the final photograph that is made after the development process

rangefinder (rānj′ fīn′ dər) a camera with a focusing device that finds out the distance between the camera and the subject

shutter (shət′ ər) the little "door" behind the lens of a camera that opens and shuts to let light in

single lens reflex (sing′ gəl lenz rē′ fleks′) a camera that uses the same lens for viewing and for taking the picture

"snapshot" camera (snap′ shät′ kam′ ə rə) a simple amateur camera that has film loaded by cartridge and few adjustments

tungsten (təng′ stən) a light for photography consisting of a large light bulb in a metal reflector

twin lens reflex (twin lenz rē′ fleks′) a camera that uses two lenses to focus a scene

INDEX

aperture 17, 23, 31, 33, 34, 38, 41, 43

ASA 32, 33

automatic camera 43

camera obscura 10, 11, 12, 15, 37

color pictures 28

Daguerre, Francois 13, 45

daguerreotypes 13

developer 26

exposure 26, 31, 32

f-stop number 17, 31, 33, 43

film 6, 18, 21, 23, 26, 27, 28, 29, 31, 32, 33, 37, 38, 41, 45

film plane 18, 21, 23, 28, 31, 38

filters 44

fixer 26

focus 18, 23, 37, 39, 40, 41

lens 10, 15, 18, 19, 21, 23, 37, 38, 39, 40

light meter 31, 32, 43

negative 26, 27, 29

Niépce, Joseph 12, 13

positive 27

print 27, 29

rangefinder 37, 39

shutter 15, 16, 17, 23, 31, 33, 34, 35, 38, 43, 44

single lens reflex 37, 38, 40

transparencies 29

tripod 41, 43

view camera 37, 41

viewfinder 39, 41

INDEX OF PHOTOGRAPHERS

Bostrom, Roald 18, 19, 20, 27, 29, 32, 33, 34

Cameron, Julia Margaret 8

Cosindas, Marie 36

Curtis, Edward S. 14

Dalton, Stephen 42

Levitt, Helen 22

Niépce, Joseph 12

Smith, W. Eugene 4

Weston, Edward 30